THE
Wisdom
OF
Wonder
Woman

By Signe Bergstrom

Wonder Woman created *by*
William Moulton Marston

CHRONICLE BOOKS

SAN FRANCISCO

PUB CHBO41172

Wonder Woman was created by William Moulton Marston.

Library of Congress Cataloging-in-Publication Data
Names: Bergstrom, Signe, author.
Title: The Wisdom of Wonder Woman / by Signe Bergstrom.
Description: San Francisco : Chronicle Books, [2019]
Identifiers: LCCN 2018041003 | ISBN 9781452173955 (hardcover : alk. paper)
Subjects: LCSH: Wonder Woman (Fictitious character)--Quotations. | DC Comics, Inc--Characters. |
Women superheroes. | Women heroes.
Classification: LCC PN6728.W6 B46 2019 | DDC 741.5/973--dc23 LC record available at https://lccn.loc.
gov/2018041003

Manufactured in China

FSC
MIX
Paper
FSC® C136333

Compilation and introduction by Signe Bergstrom
Design by Michael Morris

10 9 8 7 6 5 4 3 2

Chronicle books and gifts are available at special quantity discounts to corporations,
professional associations, literacy programs, and other organizations. For details
and discount information, please contact our corporate/premiums department at
corporatesales@chroniclebooks.com or at 1-800-759-0190.

Chronicle Books LLC
680 Second Street
San Francisco, California 94107
www.chroniclebooks.com

"As lovely as Aphrodite—
as wise as Athena—with the
speed of Mercury and the
strength of Hercules—she is
known only as Wonder Woman,
but who she is, or whence she
came, nobody knows!"

—*All Star Comics* #8, "Introducing Wonder Woman," 1941,
William Moulton Marston

As Wise As Athena:

AN INTRODUCTION

In a comic book world long dominated by male heroes and villains alike, Wonder Woman burst onto the scene in 1941. Created by Dr. William Moulton Marston, a man who also helped develop the lie detector test, Wonder Woman hailed from an island of women who had lived apart from man since the time of Ancient Greece, where she was also an Amazon princess, complete with a tiara and matching bullet-deflecting bracelets. After her release, Wonder Woman quickly moved up the comic book ranks; by 1942, she had joined the Justice Society of America as its only female member, and could boast a readership on par with DC Comics's other top-tier talents, Superman and Batman. She's got legs, too: For over seven decades, Wonder Woman's never gone out of print.

Over the years, Wonder Woman has endured plenty of costume changes, storylines, and complicated character reboots, as well as a rapidly changing cultural, social, and media climate around her readers, and her voice has morphed accordingly. But through a strong moral compass and the talent of more than a few good writers—Greg Rucka, George Pérez, and Gail Simone, among countless others, including Allan Heinberg, who wrote the screenplay to Patty Jenkins's blockbuster 2017 film—Wonder Woman always returns to her core sense of self. She may be an expert at wielding a sword or pinging away bullets with the flick of a wrist, but it's her sense of compassion, her unwavering belief in the truth, and her ability to calmly broker peace in the face of hot-headed war talk that sets her apart from her contemporaries. As author Gail Simone wrote, "When you need to stop an asteroid,

you get Superman. When you need to solve a mystery, you call in Batman. But when you need to end a war, you get Wonder Woman." If Wonder Woman can convince one person to lay down their weapon without having to raise her fist, she's stopped more than just a battle; she's won the war.

Perhaps more than any other weapon at her disposal, Wonder Woman relies on the Golden Lasso of Truth to aid in her negotiations for peace. As a seeker of truth herself, Wonder Woman also speaks the truth; she prefers to use language to her advantage, either cutting enemies to the quick with a pointed word or expounding on global injustices and delivering monologues of historic proportion that make even her staunchest enemies reconsider their actions. She's also been known to persuade her closest allies to forego their own considerable strengths in favor of her fighting strategies.

However, Wonder Woman is by no means purely diplomatic—she can speak from the heart, too. She's a woman unafraid to state her mind and reveal her feelings, a combination that takes true courage. For those individuals already engaged in the fight for peace, justice, and truth, her words are an inspiring battle cry and, for those yet to commit to the good fight, they're a potent reminder of heroic potential.

This collection of quotes represents Wonder Woman at her best: even when she's under attack or at her most vulnerable, she still finds ways to offer insight, encouragement, and inspiration. She extends a hand to her enemies, and offers peace whenever she can. Today, braced by the love of her fans, her wisdom has become a global rebel yell for people aching for a world of truth and understanding, a place where love is worth fighting for and the innocent are worth protecting. More powerful than any shield, as sharp as any sword, and as motivating as the Lasso of Truth itself, Wonder Woman's words may be her greatest strength. Let them be yours, too.

Go in peace, my daughter. And, remember that, in a world of ordinary mortals, you are a Wonder Woman.

—Queen Hippolyte

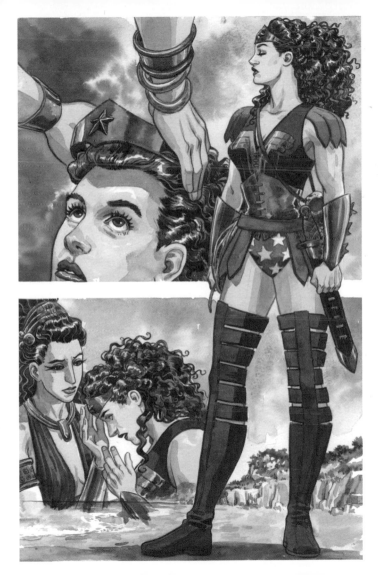

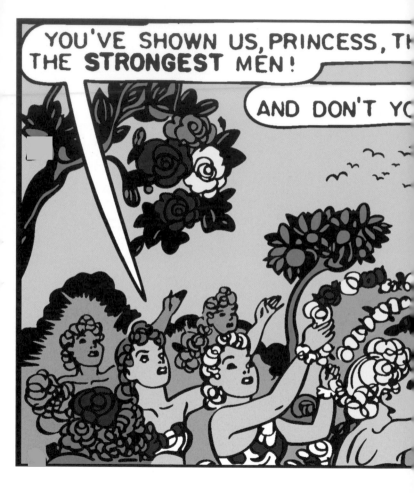

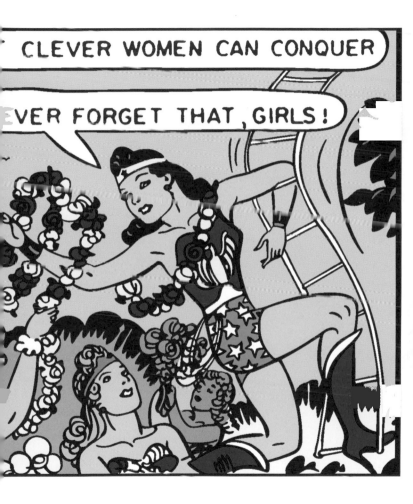

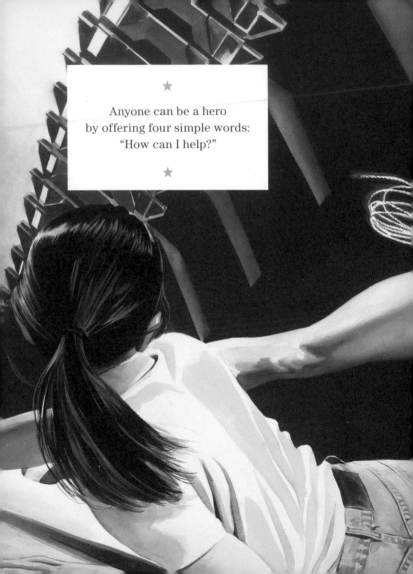

Anyone can be a hero
by offering four simple words:
"How can I help?"

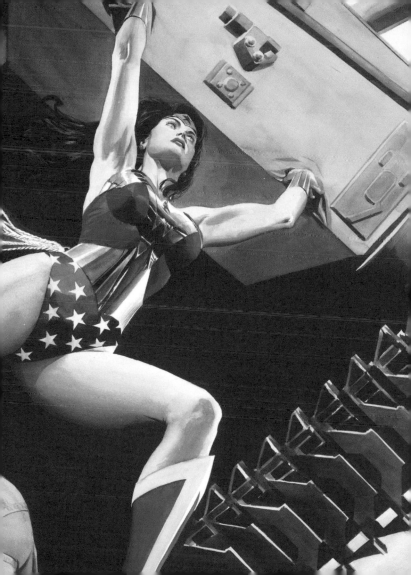

Our great world continues to be a place of wonder and delight. But it continues to be a land of great cruelty and even evil, whose most pernicious forces fight to strip from us independence, our liberties, even our lives. But there are those who find the spirit every day to struggle, even just a little bit, against the dark forces for what they believe in: for truth, and justice, and compassion.

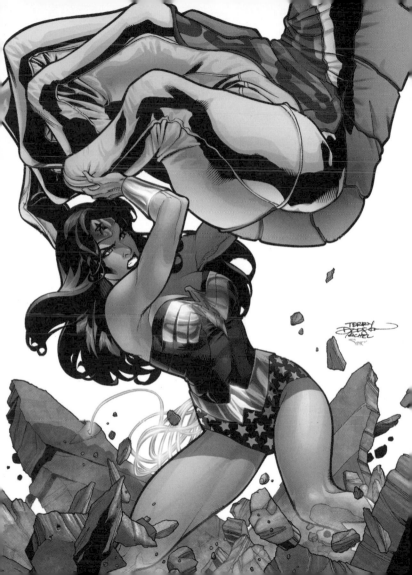

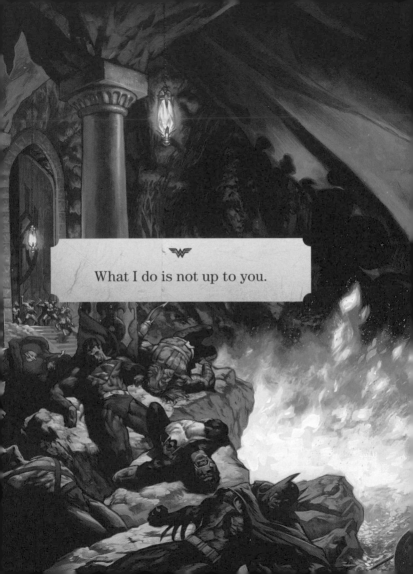

What I do is not up to you.

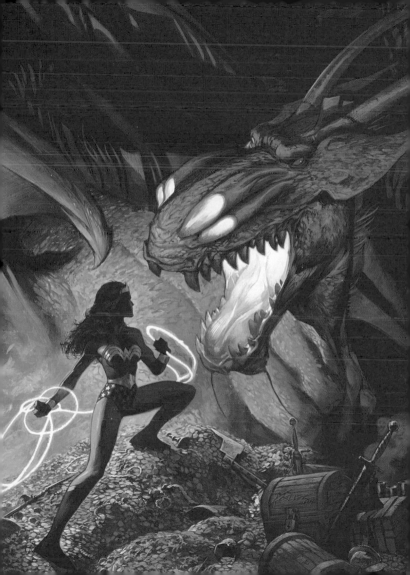

I hate to break it to you both, but I dress this way because I want to, not to provoke or impress you.

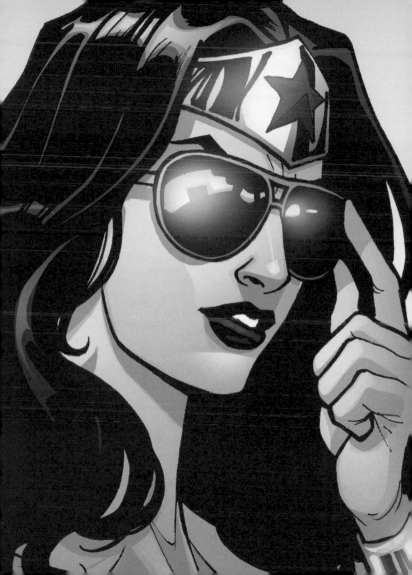

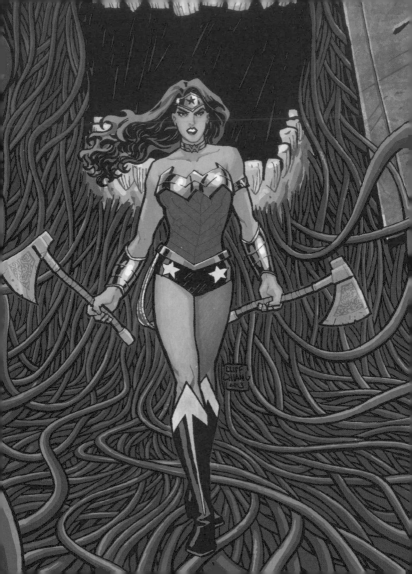

* * * * *

Aphrodite forbids us
Amazons to let any
man dominate us.
We are our
own masters.

* * * * *

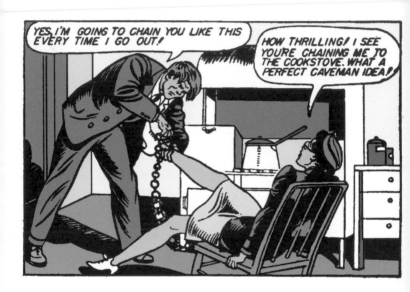

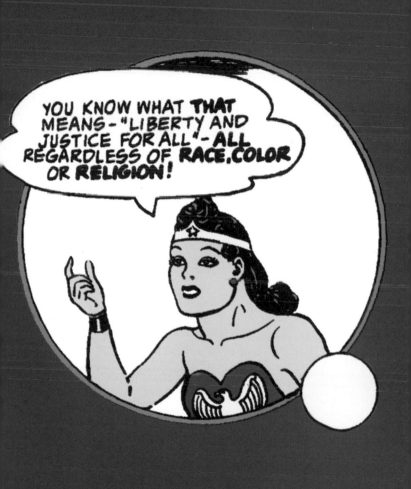

Peace is a virtue.
A state of mind,
a disposition for benevolence,
confidence, and justice.
It is not simply the
absence of war.

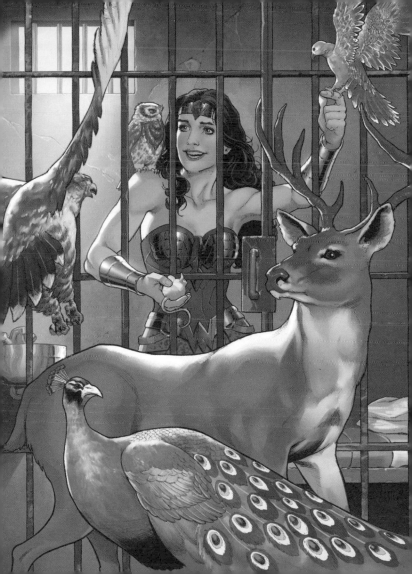

She Can Do It!

I'm the man
who can!

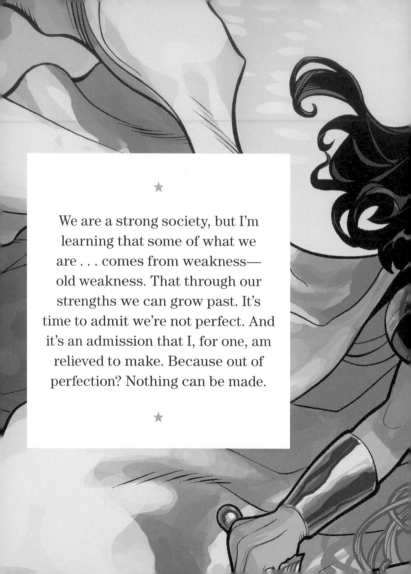

We are a strong society, but I'm learning that some of what we are . . . comes from weakness—old weakness. That through our strengths we can grow past. It's time to admit we're not perfect. And it's an admission that I, for one, am relieved to make. Because out of perfection? Nothing can be made.

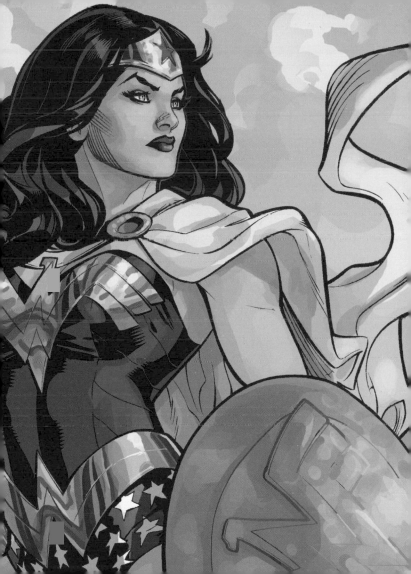

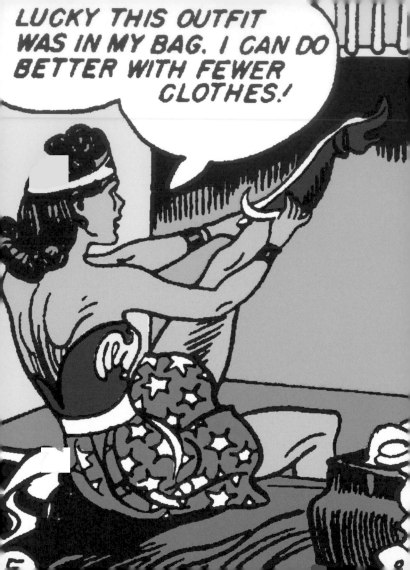

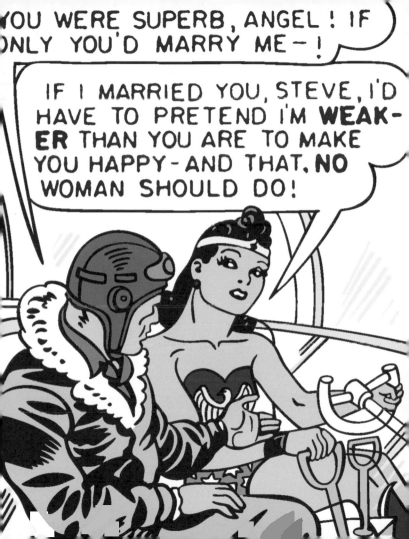

Remember, the better you can fight the less you'll have to.

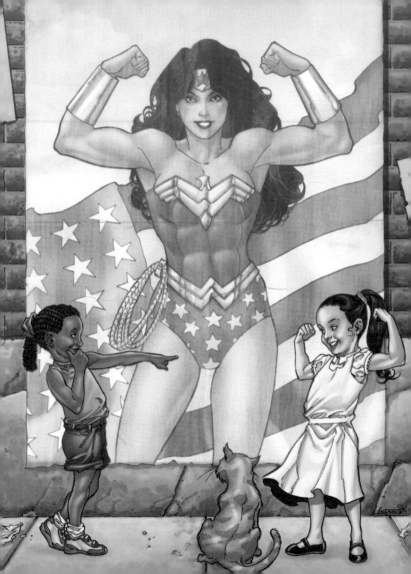

Women are the wave of the future, and sisterhood is stronger than anything!

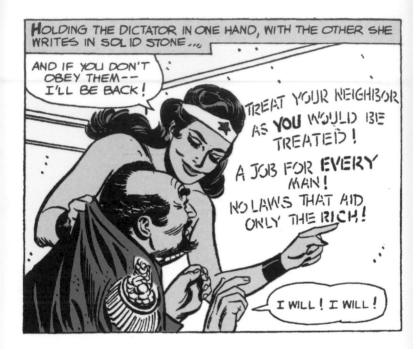

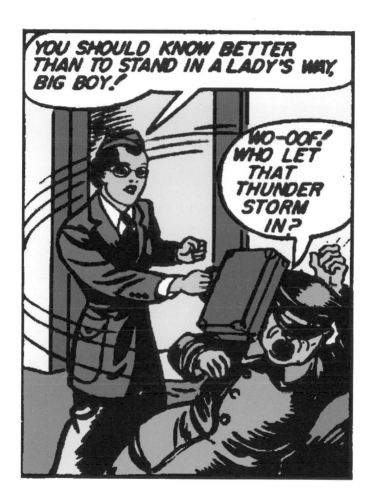

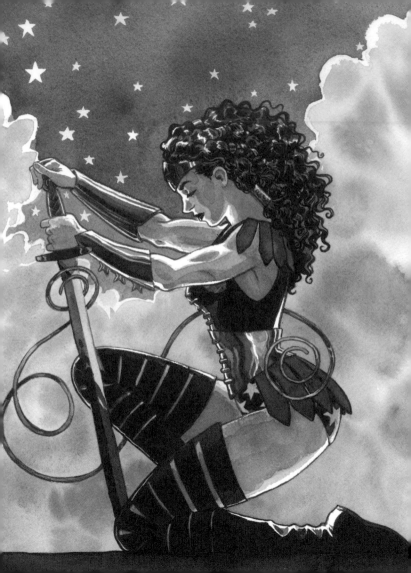

Power without
self-control tears
a girl to pieces.

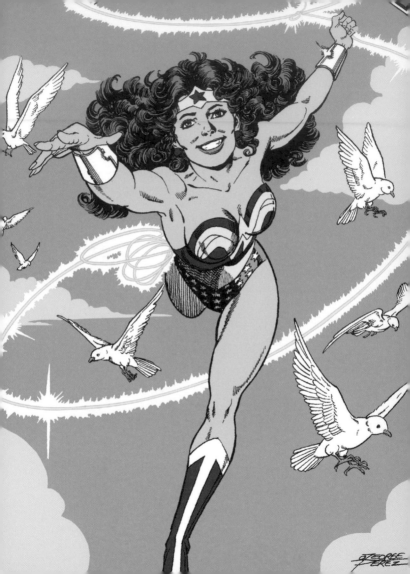

If just for a moment, have faith
in my dream of peace . . . Please
take my hand. I give it to you as
a gesture of friendship and love,
and of faith freely given. I give
you my hand and welcome you
into my dream.

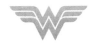

We can change the
rules of this game.
But first we have
to trust each other.
Like family.

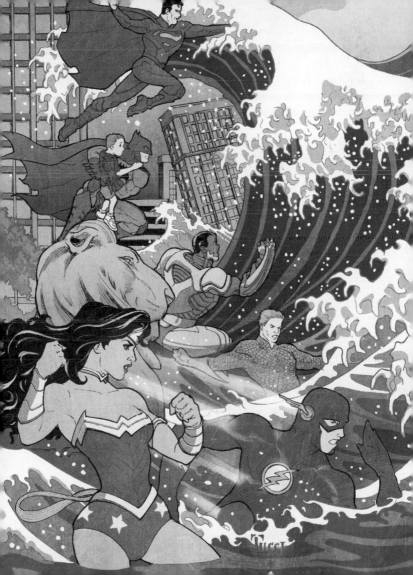

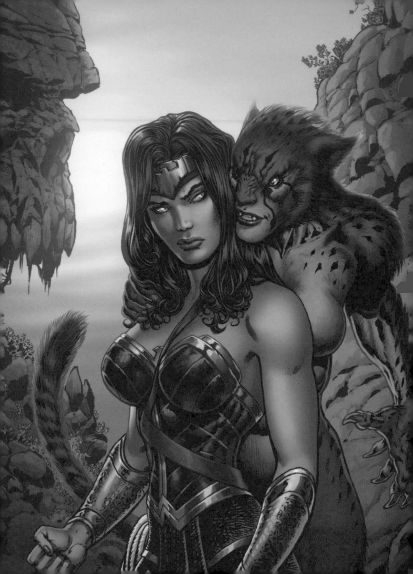

★

Having power and
knowing how to use it
aren't the same thing.

★

I came here to parley. But do not mistake a desire to avoid violence for the inability to deal it.

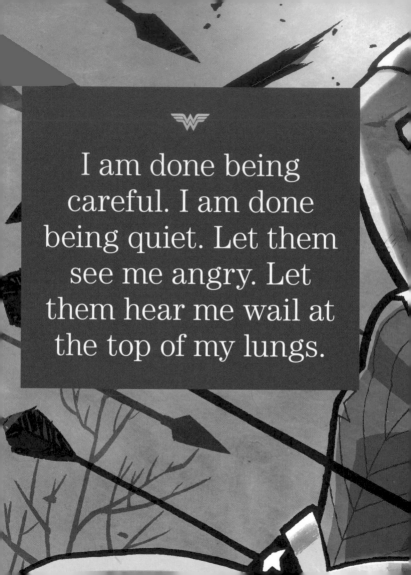

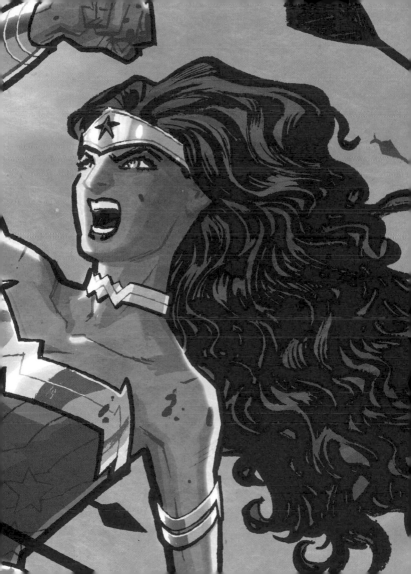

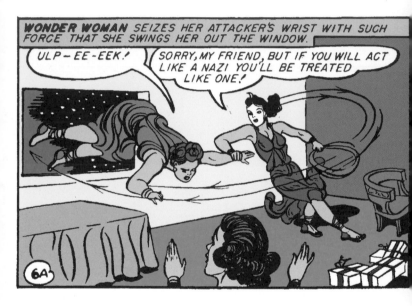

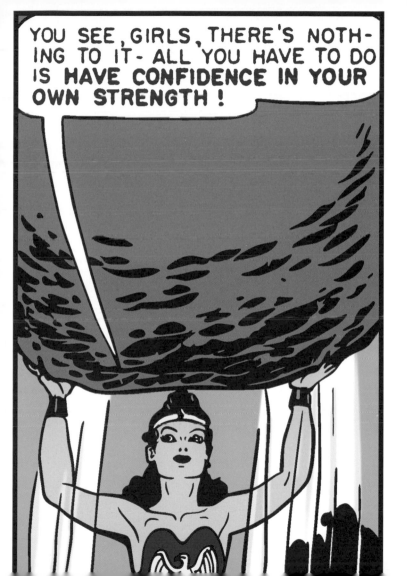

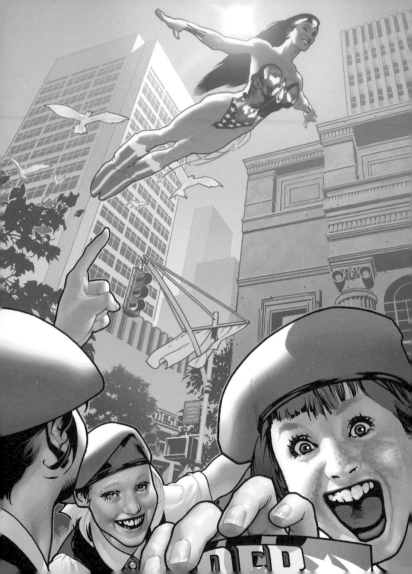

Sometimes, it's best not to be who we are . . . but who we aspire to be.

If the prospect of living in a world where trying to respect the basic rights of those around you and valuing each other simply because we exist are such daunting, impossible tasks that only a superhero born of royalty can address them, then what sort of world are we left with? And what sort of world do you want to live in?

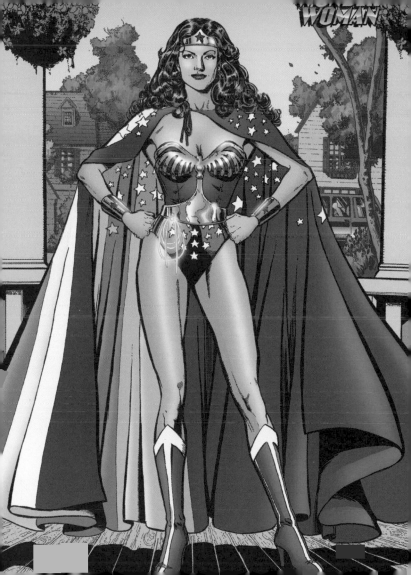

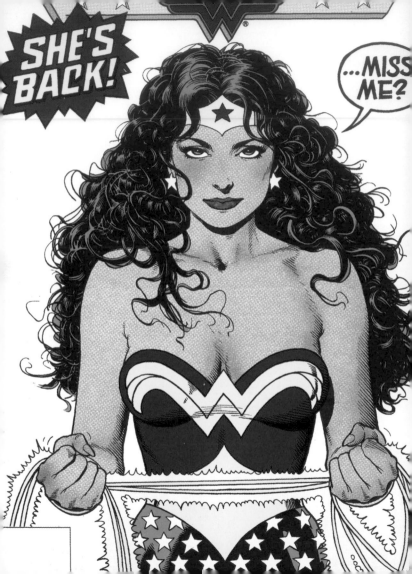

The only way you can rule
anybody, Steve, is the way we
women do it—by inspiring
affection!

Oh, you stupid girls! When you let your men bind you— you let yourself be bound by war, hate, greed, and lust for power! Think! And free yourselves! Control those who would oppress others. You can do it!

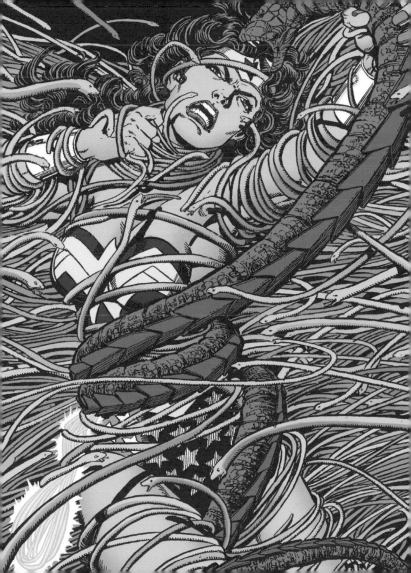

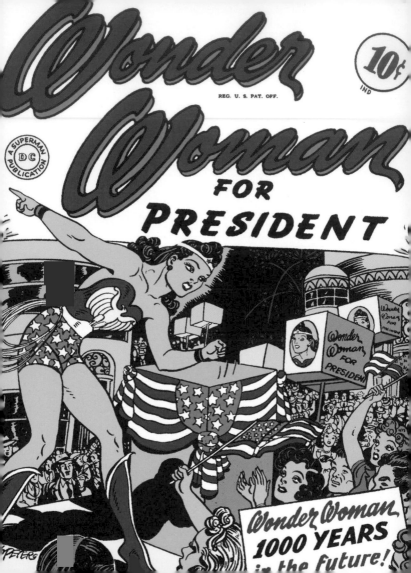

★ ★ ★

Athena once said that America was the last citadel of democracy and equal rights for women. I think I might have to stick around and make sure that it comes true.

★ ★ ★

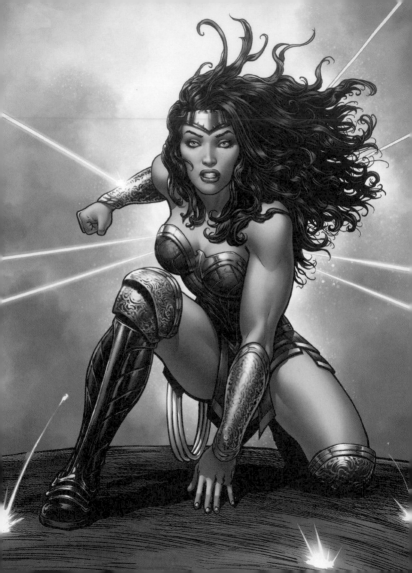

If loss makes you doubt
your belief in justice, then
you never truly believed in
justice at all.

The truth . . .
is my weapon.

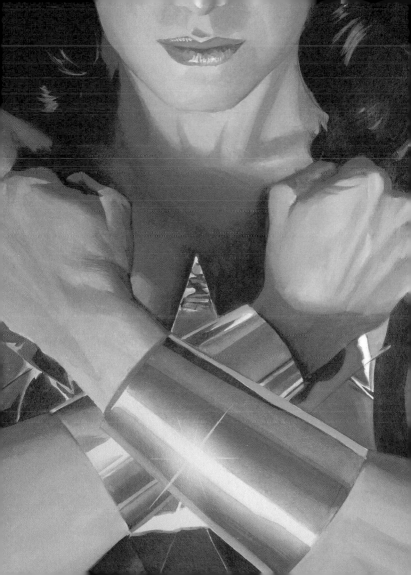

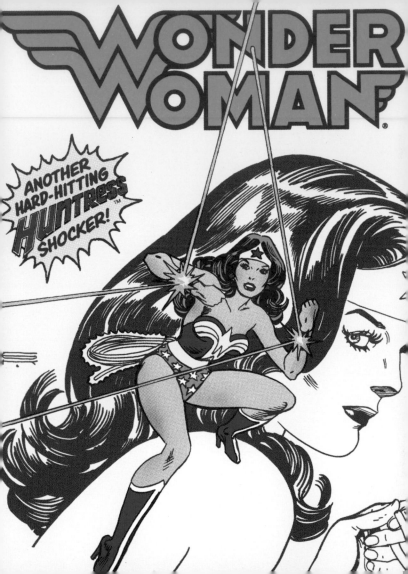

★ ★ ★ ★ ★

I fight for those
who cannot fight
for themselves.

★ ★ ★ ★ ★

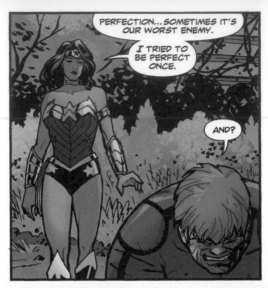

PERFECTION...SOMETIMES IT'S OUR WORST ENEMY.

I TRIED TO BE PERFECT ONCE.

AND?

DECIDED TO JUST TRY TO BE *BETTER.*

FOUND A *GOOD* WAY TO START THAT...

...IS BY ACCEPTING WHO YOU ARE.

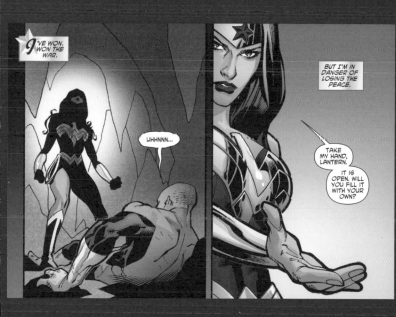

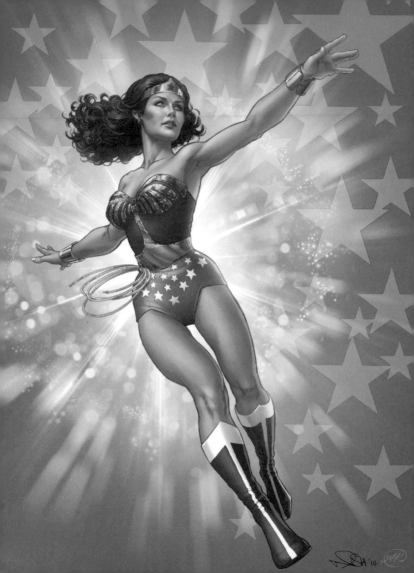

★　★　★　★　★

Heroes fight for the
right thing. They
don't always win, but
they're still heroes.

★　★　★　★　★

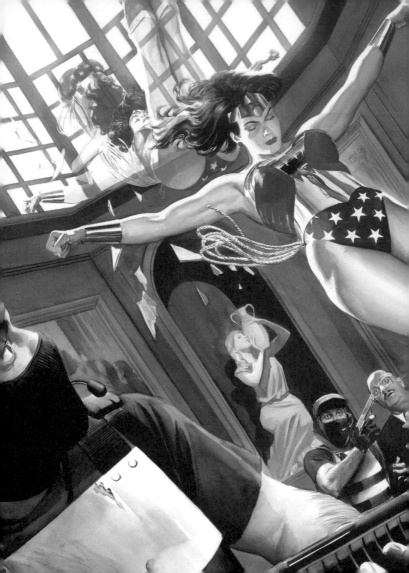

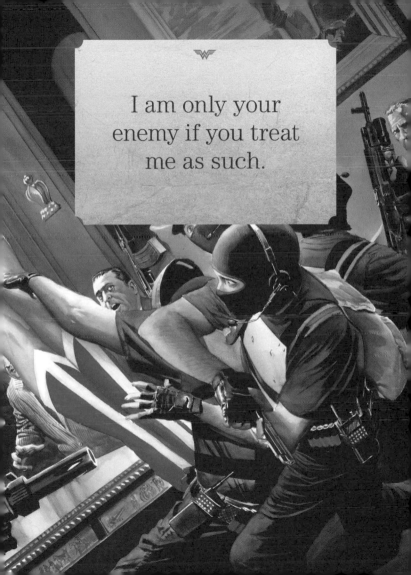

I am only your enemy if you treat me as such.

★　★　★　★　★

And between my prayers I made a vow
that I would always be aware of my
strength. And that of my opponents,
my friends, and my victims.

★　★　★　★　★

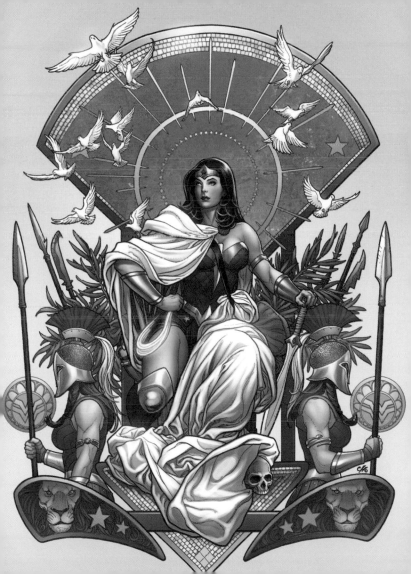

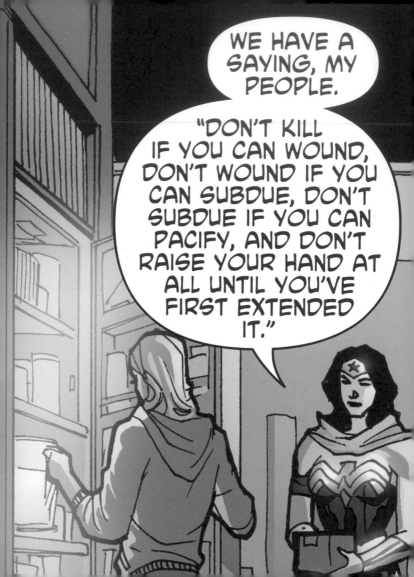

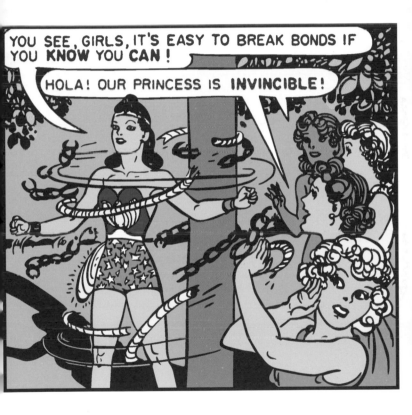

So now we prepare to turn to
another blank page . . .
A new journey to be started.
A new promise to be fulfilled.
A new page to be written.
Go forth unto this waiting world with
pen in hand, all you young scribes,
the open book awaits.
Be creative.
Be adventurous.
Be original.
And above all else, be young.
For youth is your greatest weapon,
your greatest tool.
Use it wisely.

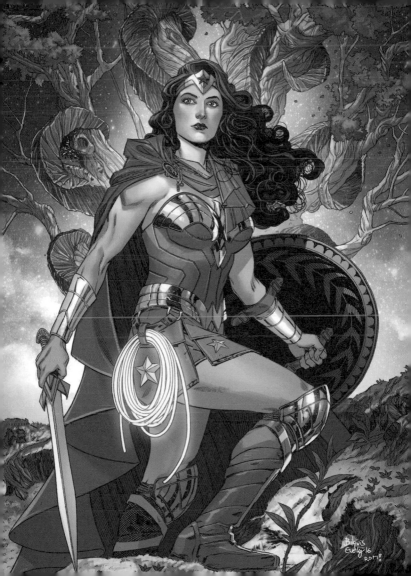

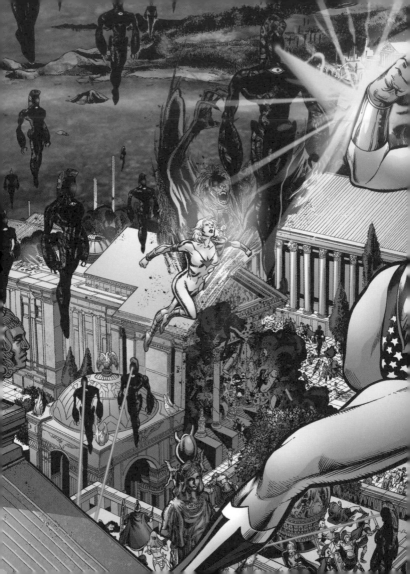

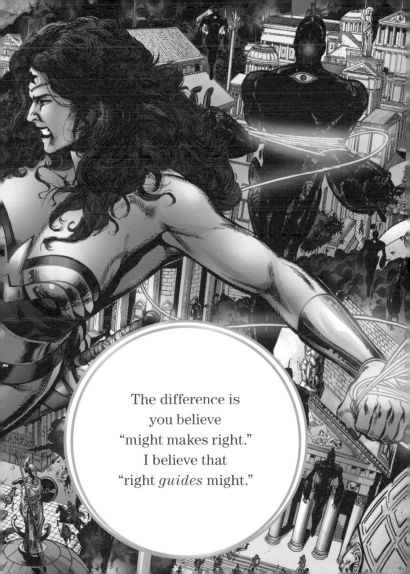

The difference is
you believe
"might makes right."
I believe that
"right *guides* might."

Bonds of love never
make the wearer
weaker—they give
him greater strength!

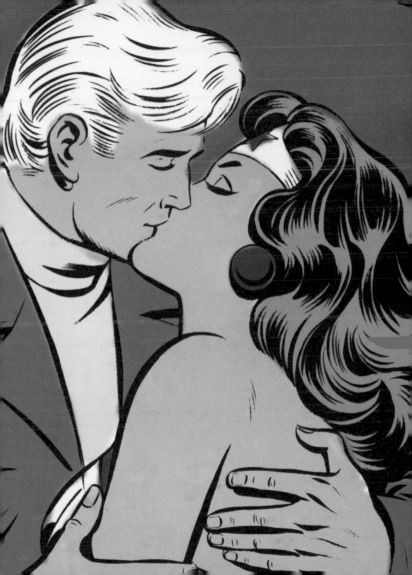

Next time anyone says you can't like something, put this in their hand and ask them again. Because the truth is: *Being true to yourself is never wrong.*

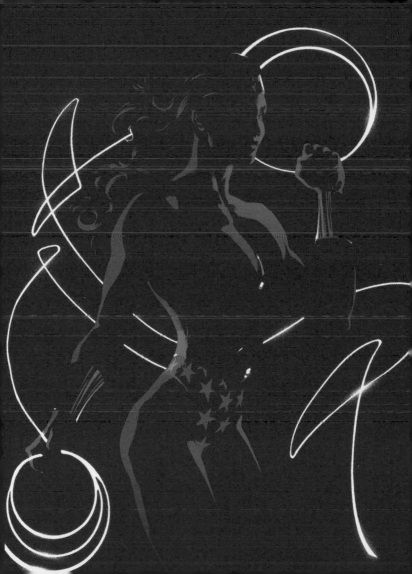

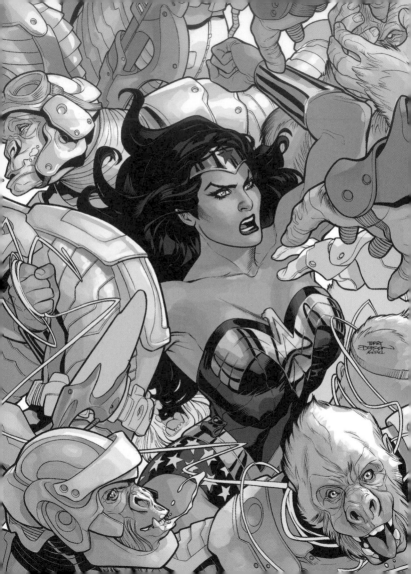

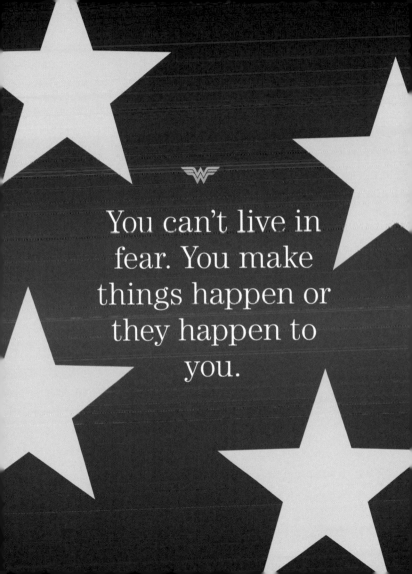

You can't live in fear. You make things happen or they happen to you.

★ ★ ★ ★ ★

It takes real character to admit one's
failures—and not a little wisdom
to take your profits from defeat.
But remember, this man's world of
yours will never be without pain and
suffering until it learns love, and
respect for human rights. Keep your
hands extended to all in friendliness
but never holding the gun of
persecution and intolerance!

★ ★ ★ ★ ★

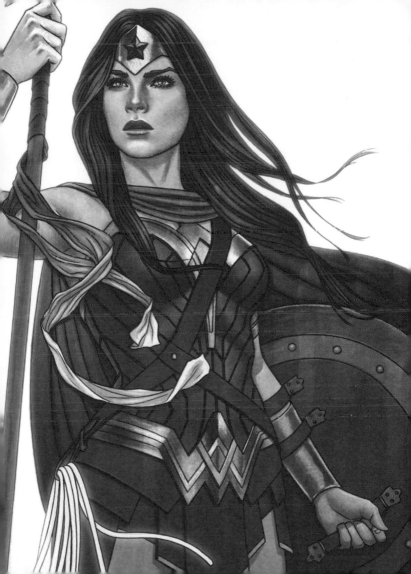

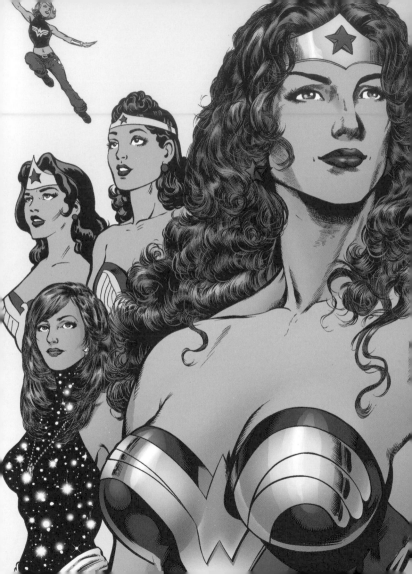

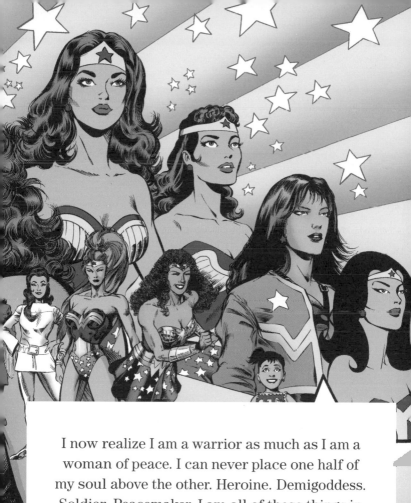

I now realize I am a warrior as much as I am a woman of peace. I can never place one half of my soul above the other. Heroine. Demigoddess. Soldier. Peacemaker. I am all of these things in part, yet none of them completely.

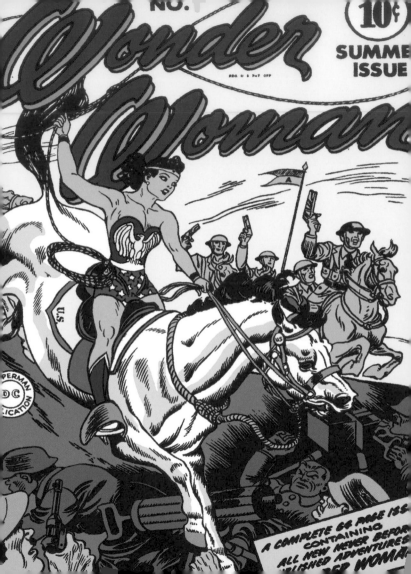

The first casualty
in war, after all,
is truth.

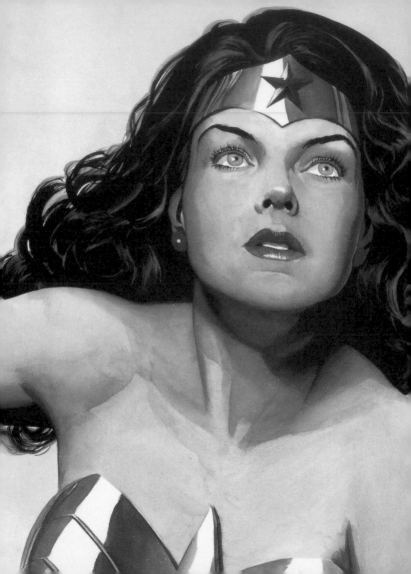

Fight on as before—
we will show those evil
men that women fight
for peace harder than
men can satisfy their
greed!

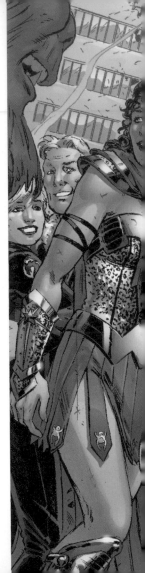

Aphrodite's way is one of compassion and eternal hope! Without those, we are nothing!

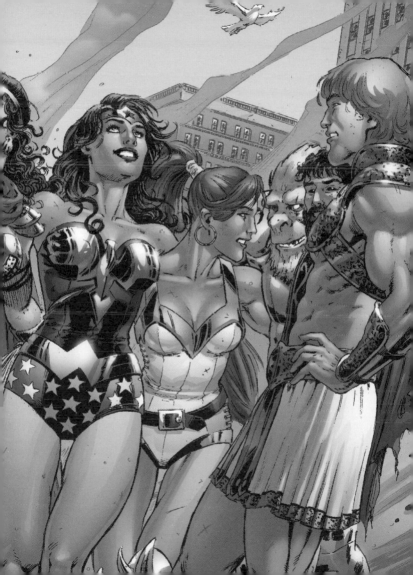

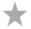

If you cannot bear our
pain, you are not fit to
carry our strength.

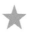

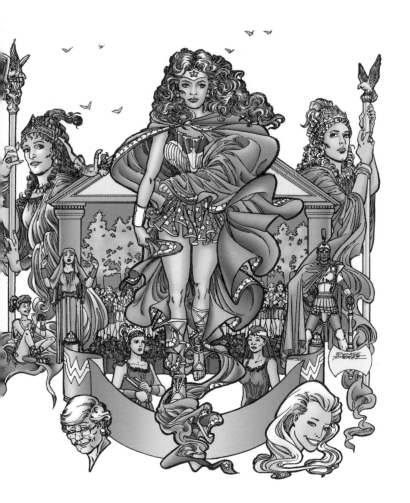

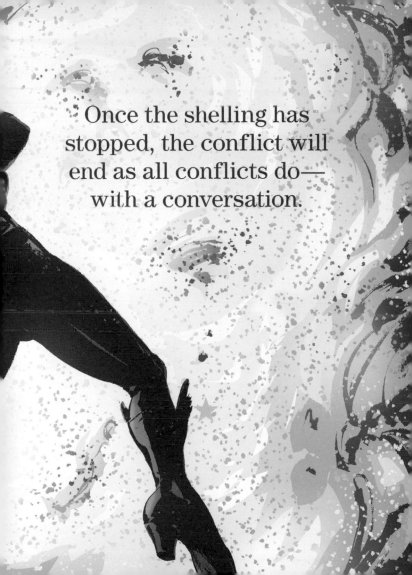

Once the shelling has stopped, the conflict will end as all conflicts do— with a conversation.

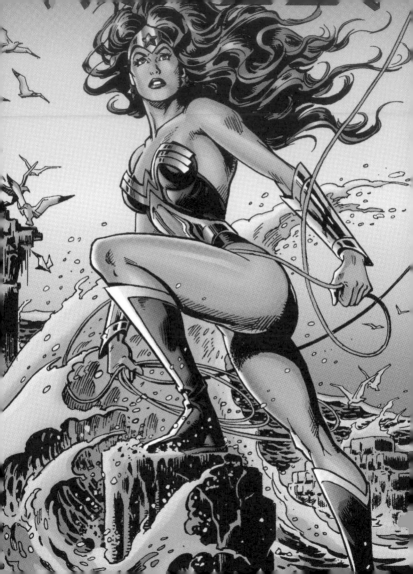

If it means interfering in an ensconced, outdated system, to help just one woman, man, or child . . . I'm willing to accept the consequences.

I am strong. I am a warrior. I am an Amazon. I am a woman of hope and peace. And I am free.

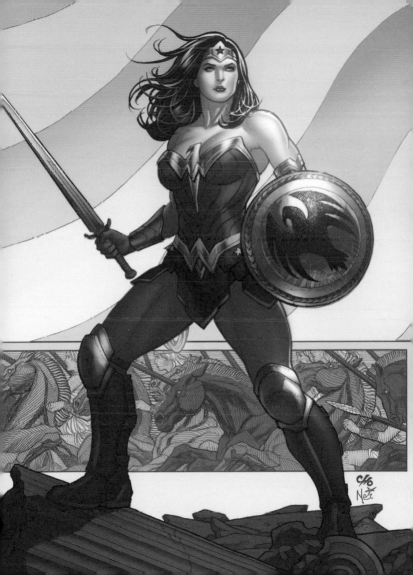

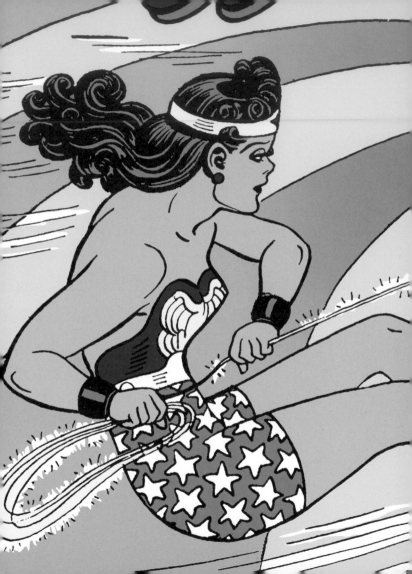

Only love can truly
save the world.

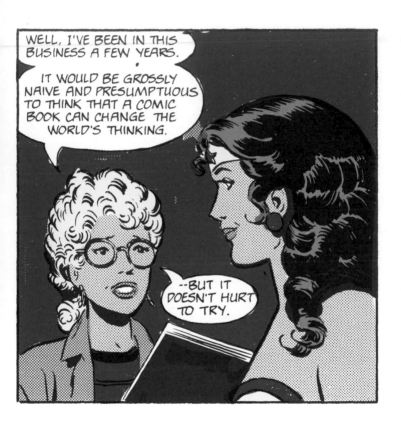

QUOTE CREDITS:

6: *Wonder Woman* TV show, "The New Original Wonder Woman," 1975

8-9: *Wonder Woman* (Vol. 1) #13, "The Icebound Maidens," 1945, Joye Murchison

10-11: *Sensation Comics Featuring Wonder Woman* (Vol. 1) #16, "A Day in Our Lives," 2015, Jason Badower

12: *Wonder Woman* (Vol. 2) #188, "Wonder Boys," 2003, Phil Jimenez

14: *Wonder Woman*, film, 2017, Allan Heinberg

16: *Sensation Comics Featuring Wonder Woman* (Vol. 1) #3, "Bullets and Bracelets," 2014, Sean E. Williams

19: *Comic Cavalcade* #8, "The Amazon Bride," 1944, William Moulton Marston

20: *Sensation Comics* (Vol. 1) #9, "The Return of Diana Prince," 1942, William Moulton Marston

21: *All-Star Comics* (Vol. 1) #22, "A Cure for the World," 1944, Gardner Fox

22: *Wonder Woman* (Vol. 2) #199, "Down to Earth Part Four," 2004, Greg Rucka

25: *Wonder Woman*, film, 2017, Allan Heinberg

26: *Wonder Woman* (Vol. 4) #31, "This Monster's Gone Eleven," 2014, Brian Azzarello

28: *Sensation Comics* (Vol. 1) #2, "The Menace of Doctor Poison," 1942, William Moulton Marston

29: *Wonder Woman* (Vol. 1) #13, "The Icebound Maidens," 1945, Joye Murchison

30: *Wonder Woman* (Vol. 1) #5, "Battle for Womanhood," 1943, William Moulton Marston

33: *Wonder Woman* TV show, "The New Original Wonder Woman", 1975

34: *Justice League of America* (Vol. 1) #40, "Indestructible Creatures of Nightmare Island," 1965, Gardner Fox

35: *Sensation Comics* (Vol. 1) #7, "The Milk Swindle," 1942, William Moulton Marston

37: *Sensation Comics* (Vol. 1) #19, "The Unbound Amazon," 1943, William Moulton Marston

39: *Wonder Woman* (Vol. 2) #167, "Gods of Gotham Pt 4: Faith," 2001, Phil Jimenez

40: *Trinity* (Vol. 2) #3, "Better Together, Part Three: Nobody Dies Tonight," 2017, Francis Manapul

43: *Superman/Batman: Apocalypse*, film, 2010, Tab Murphy

45: *Sensation Comics Featuring Wonder Woman* (Vol. 1) #11, "Vendetta," 2015, Josh Elder

46: *Wonder Woman: Warbringer* (DC Icons Series), 2017, Leigh Bardugo

48: *Wonder Woman* (Vol. 1) #3, "A Spy on Paradise Island," 1943, William Moulton Marston

49: *Wonder Woman* (Vol. 1) #13, "The Icebound Maidens," 1945, Joye Murchison

51: *Wonder Woman* (Vol. 4) #23, "God Down," 2013, Brian Azzarello

52: *Wonder Woman* (Vol. 2) #170, "She's a Wonder!" 2001, Phil Jimenez and Joe Kelly

55: *Sensation Comics* (Vol. 1) #62, "Mysterious Prisoners of Anglonia," 1947, William Moulton Marston

56: *Wonder Woman* (Vol. 1) #32, "The Amazing Global Thefts," 1948, Robert Kanigher

59: *Sensation Comics Featuring Wonder Woman* (Vol. 1) #3, "Bullets and Bracelets," 2014, Sean E. Williams

61: *Wonder Woman* (Vol. 3) #19, "Expatriate, Part 2: Lifeblood," 2008, Gail Simone

62: *Wonder Woman* (Vol. 4) #7, "Il Gangster Dell'Amore," 2012, Brian Azzarello

65: *Wonder Woman*, film, 2017, Allan Heinberg

66: *Wonder Woman* (Vol. 4) #22, "The Calm," 2013, Brian Azzarello

67: *Wonder Woman* (Vol. 3) #19, "Expatriate, Part 2: Lifeblood," 2008, Gail Simone

69: *Wonder Woman '77 Special* (Vol. 1) #4, "The Man Behind the Curtain," 2016, Marc Andreyko

70-71: *Wonder Woman: Rebirth* (Vol. 5) #1, "The Lies: Part One," 2016, Greg Rucka

7: *Wonder Woman: The True Amazon*, 2005, Jill Thompson

8–9: *Wonder Woman* (Vol. 1) #13, "The Icebound Maidens," 1945, Harry G. Peter

10–11: *Wonder Woman: Spirit of Truth*, 2001, Alex Ross

13: *Wonder Woman* (Vol. 3) #2, "Who Is Wonder Woman? Part 2 of 5," 2006, Terry Dodson (pencils), Rachel Dodson (inks), Alex Sinclair (colors)

14–15: *JLA: A League of One*, 2000, Christopher Moeller (cover)

17: *Wonder Woman* (Vol. 3) #25, "Personal Effects," 2008, Bernard Chang (pencils, inks), Kanila Tripp (colors)

18: *Wonder Woman* (Vol. 4) #23, "God Down," 2013, Cliff Chiang (cover)

20: *Sensation Comics* (Vol. 1) #9, "The Return of Diana Prince," 1942, Harry G. Peter

21: *All-Star Comics* (Vol. 1) #22, "A Cure for the World," 1944, Joe Gallagher (pencils, inks)

23: *Wonder Woman* (Vol. 5) #6, "Year One: Part 3," 2016, Nicola Scott (pencils, inks), Romulo Fajardo, Jr. (colors)

24: *Wonder Woman* Vol 4 #32, "The Beast of Times," 2014, Ant Lucia (variant cover)

26–27: *Wonder Woman* (Vol. 3) #13, "Mothers & Daughters," 2007, Terry and Rachel Dodson (cover)

28: *Sensation Comics* (Vol. 1) #2, "The Menace of Doctor Poison," 1942, Harry G. Peter

29: *Wonder Woman* (Vol. 1) #13, "The Icebound Maidens," 1945, Harry G. Peter

30–31: *Sensation Comics Featuring Wonder Woman* (Vol 1) #1, "Gothamazon," 2014, Ethan Van Sciver (pencils, inks), Brian Miller (colors)

32: *Wonder Woman* (Vol. 3) #25, "Personal Effects," 2008, Aaron Lopresti (cover)

34: *Justice League of America* (Vol. 1) #40, "Indestructible Creatures of Nightmare Island!," 1965, Mike Sekowsky (pencils), Bernard Sachs (inks), Gaspar Saladino (letters)

35: *Sensation Comics* (Vol. 1) #7, "The Milk Swindle," 1942, Harry G. Peter

36: *Wonder Woman: The True Amazon*, 2005, Jill Thompson

38: *Wonder Woman* (Vol. 2) #22, "Through Destiny's Door," 1988, George Pérez (cover)

41: *Justice League* (Vol. 2) #15, "Throne of Atlantis: Chapter One," 2013, William Tucci (variant cover)

42: *Wonder Woman* (Vol. 5) #3, "The Lies: Part Two," 2016, Liam Sharp (pencils, inks), Laura Martin (colors)

44: *Sensation Comics Featuring Wonder Woman* (Vol. 1) #11, "Vendetta," 2015, Jamal Igle (pencils), Juan Castro (inks), Wendy Broome (colors)

46–47: *Wonder Woman* (Vol. 4) #1, "The Visitation," 2011, Cliff Chiang (cover)

48: *Wonder Woman* (Vol. 1) #3, "A Spy on Paradise Island," 1943, Harry G. Peter

49: *Wonder Woman* (Vol. 1) #13, "The Icebound Maidens," 1945, Harry G. Peter

50: *Wonder Woman* (Vol. 2) #177, "Paradise Found," 2002, Adam Hughes (cover)

53: *Wonder Woman* (Vol. 2) #188, "Wonder Boys," 2003, Phil Jimenez (pencils), Andy Lanning (inks), Trish Mulvihill (colors), Wildstorm FX (seps)

54: *Wonder Woman* (Vol. 2) #63, "Operation. Cheetah Part Two," 1992, Brian Bolland (cover)

57: *Wonder Woman* (Vol. 2) #5, "The Ares Assault," 1987, George Pérez (cover)

58: *Wonder Woman* (Vol. 1) #7, "The Adventure of the Life Vitamin," 1943, Harry G. Peter (cover)

60: *Wonder Woman* Vol 5 #21, "The Truth, Part Four," 2017, Liam Sharp (pencils, inks), Laura Martin (colors)